MW01016549

THE
WOMAN'S WAY

THE
WOMAN'S WAY

Celebrating Life After 40

Regan Marie Brown

STARK BOOKS

**Andrews McMeel
Publishing**

Kansas City

01 02 03 04 05 RDR 10 9 8 7 6 5 4 3 2 1

Library of Congress Cataloging-in-Publication Data

Brown, Regan Marie.
 The woman's way : celebrating life after 40 / Regan Marie Brown.
 p. cm.
 ISBN: 0-7407-0761-2
 1. Middle aged women—Psychology—Miscellanea. 2. Middle aged women—
Conduct of life. I. Title.

HQ1059.4 .B76 2001
305.244—dc21 00-063570

Book design by Holly Camerlinck

In memory of Dottamus
Dorothy Melland Huntsman, 1931–2000
dreamer, writer, book lover, mother

ACKNOWLEDGMENTS

For many words and acts of encouragement, kindness, inspiration, and friendship I am grateful to Shari Brown, James Cramer, Paula Etzel, J. D. Fairbanks, Tara Fatemi, Rob Huesca, Jessica Kerrigan, Del Knauer, Bones Ownbey and family, Gary Shaw, Gladys Smisor, Emily Weida, and Jinx Wright.

I am deeply grateful to all the women of my family of origin, especially Cordelia, Dorothy, Rebecca, Geneva, Lorena, Marie, Madeleine, and Innocenza; the Austin Writergrrls, especially Emly Vander Veer, Wendy Wheeler, Ann Marie Turner, Leslie Forbes, Mimi Mayer, Kim Lane, Beverly Horne, Lisa Bland, and Michelle Grant; Austin psychic extraordinaire Joe Nicols; the makers of Diet Dr. Pepper; and my colleagues in the Copy Cabana: John Ratliff, Cecilia Mena, Stacie Herrington, and Kenny Attal.

Warmest thanks of all to two Texans whose belief in me took many forms and never seemed to waver: Don Freidkin and Cotton Inks.

Forty is the noon of life.
Carl Gustav Jung (1875-1961)

Ask any honest woman over forty. Every last one of us would kill to have our current wise, evolved, road-tested soul magically transplanted into the body of a twenty-two-year-old, or even a seven-year-old. And by the time we reach our prime years, most of us have a pretty good idea of what we'd like to be in our next lives—a surprising number of my friends, for example, intend to come back as dolphins. Let's hope that next time around we can all share a carefree life navigating warm, unpolluted seas in the same joyous pod.

But this book isn't about yearning for bygone days that will never return, or about imagining the great future lives we hope we're earning in this one. *The Woman's Way* is about enjoying the fruits of all the lessons we learned in our formative years. It's a celebration of learning, loving, and passing it on.

News reports to the contrary, there has never been a better time to be a woman than the early years of the twenty-first century on this planet. Come on—you don't believe everything you hear on TV or read about in those magazines at the grocery store checkout line, do you? From toddlers to octogenarians, today's women have opportunities our grandmothers didn't dare to dream of.

If Jung was right about forty being the noon of life, Pollyanna me chooses to look at the bright side. Instead of counting the hours till midnight, why not appreciate the warm, golden sunshine of the afternoon and savor every hard-earned moment?

Besides—I don't know about you, but I'm no morning person. If forty is the noon of life, hey—that means I made most of my major mistakes in the morning and the next twenty or so years will be like a long, languid late-summer afternoon on a shaded veranda.

Savor, enjoy, count your blessings, and pass it all on.

You've learned the value—and the relief—
of being direct while being kind.

. . .

You've learned to nurture yourself more.

. . .

The world and the people in it have stopped being
your mirror. You know yourself well enough that
you no longer need to gauge yourself constantly by
the response of others. A longing glance from a handsome
stranger doesn't make your heart and hopes soar quite
as it used to. But on the other hand, indifference
or a disapproving word or stare no longer have
the power to ruin your day.

You've stopped dressing to get a reaction out of people or to prove you are a certain kind of person. Finally, you dress to please yourself. Those high heels in the closet come out only for high-octane nights on the town when you know you don't have to stand up for very long. Your Holy Grail these days is shoes that feel as good as they look.

. . .

By the time you've turned forty, you've probably made all of your really big mistakes.

. . .

You've stopped blaming people; you enjoy taking responsibility for your own actions and encourage others around you to do the same. Ultimately, you let blame fall away from you; it's something you learn to leave behind, look beyond, and rise above. Who needs all that negative energy?

If you've always had a pet, you find you can live without one and enjoy the freedom—for now—of no litter boxes, no late-night dog walks, and no aquarium scrubbings. If you've never shared your life with a bird, cat, dog, or fish but have always wanted to, now is a great time to discover the joys of a companion animal in your life.

• • •

Nothing can shake your growing realization that you are fine on your own, or could be if circumstances change. If you are on your own, you start to realize that giving up your freedom is not a thing to be done lightly.

Sex is terrific. Not only can you ask for what you want and get it—you find that your sexuality brings you more pleasure and joy than you might ever have dreamed of asking for. You look back with compassion at the shy girl you were once and how scary sex used to seem. ("You're going to do what to my what?!") The difference between sex in your teens or twenties and sex in your forties is like the difference between a sloe gin fizz and Dom Perignon.

. . .

If you're not in a committed relationship, you don't feel sorry for yourself the way you used to. The right partner is well worth waiting for—how many frogs did you have to kiss to figure that out? You may not know where your soul mate is, but you're willing to let him do a little work to find you. Meanwhile, you appreciate the time and energy you are able to put into all the other things you are passionate about: work, causes, pets, garden, friends, family, travel.

IF YOU ARE IN A RELATIONSHIP,
YOUR SINGLE FRIENDS ENVY YOU
FOR THE WAY YOU OPERATE CREATIVELY
WITHIN YOUR PARTNERSHIP AND
INDEPENDENTLY OUTSIDE IT.

. . .

IF YOU ARE NOT IN A RELATIONSHIP,
YOUR MARRIED FRIENDS ENVY YOU FOR
THE WAY YOU ARE ABLE TO POUR YOUR PASSION
AND ENERGY INTO YOUR CREATIVITY,
YOUR FRIENDS AND FAMILY, AND MAKING
THE WORLD A BETTER PLACE.

There's nothing left to prove.

. . .

You have the courage to take risks and the
largeness of heart to accept the consequences.

. . .

You have lost enough love and seen enough loss
to appreciate the heartbreaking fragility of babies,
dandelion fluff, young love, and idealism.

. . .

You control less and enjoy more.

You view your elders with far more compassion,
since it's looking more likely all the time that
you will become one. Every fragile, bent-over woman
with osteoporosis you see reinforces your vow
to take more calcium.

• • •

You forgive others more easily. Even more important,
you learn how to forgive yourself.

• • •

You see through a lot more. It's easier to look
behind people's defense systems and see the
fears that keep them isolated. Though you're soft
at heart, you're a lot harder to fool than
you used to be.

You are willing to take the risk of letting
people see more deeply into you. Now you realize
how much energy goes into maintaining
those defense systems.

· · ·

You're far enough from the faith you were raised in
and your earliest religious training to either
a) appreciate its basic truth and reaffirm its importance
in your life, or b) feel comfortable with finding your
own spiritual niche, in whatever form feels
right to you.

You may find that formal religion is less important
than daily spirituality. Yet you find increased meaning
and comfort in ancient rituals.

. . .

You see deeper into the core of people,
systems, and beliefs.

. . .

You savor the connected, synergistic energy of all
living things, from seaweed to sequoias.

. . .

You have learned when to hang on and when to let go—
when to speak out and when silences are best.
You choose your battles more wisely.

You know that nothing is more precious or more worth
fighting for than the right of children to be free from
abuse and neglect. Your biggest wish for the world is that
every child could be a loved, wanted, and cherished child.

• • •

Every form of love, every act of faith,
every newborn child is a miracle.

• • •

You care less all the time what people—especially strangers—
think of you. Sometimes you'd rather go against expectations
than meet them. When making new friends, you look
for people with less flash and more substance.

One day you notice that your closest circle includes
friends from every sign of the zodiac.

. . .

You look everyone you meet right in the eyes.
Sometimes you find yourself gazing straight into the soul
of a kindred spirit. Other times, you encounter fear,
indifference, or deep pain. You are strong enough
to look not just into people's eyes, but into their souls.

. . .

You do not seek out crisis, but you don't turn away
from it if there is something you can do to make
things better. You've handled enough emergencies
to keep your cool and know your strengths.

You feel a little sorry for slender young girls. Instead of being jealous, you remember what it was like to be that age—to be so conscious of your appearance that you can't enjoy your food, relax about your looks, and enjoy being yourself. Where's the fun in that? You console yourself by reflecting that if you had too flat a stomach, you'd have to wear a belt just to hold your pants up. You are proud not to have worn a belt since 1984.

· · ·

You wonder why you were in such a hurry to wear panty hose when you were young. Remember all those arguments with your mother? Looking back, you can now appreciate that your mother was probably right about a few things, like ankle socks and sensible shoes. They really are the most comfortable things you can wear on your feet.

Even if your mother was 90 percent wrong about life,
you have more compassion for her now that you are about
the age she was when she and teenaged you were making
each other's lives miserable. You have a much better
understanding now of how she was a product of her times
just as much as you are of yours. You are very grateful to
have been born exactly when you were. One of your
regrets is that your mother, grandmothers, and aunts were
not able to have the freedoms and choices
that you've enjoyed.

. . .

In a crowd, you automatically go up to the shyest person
in the room and draw her or him out.

. . .

You are more interested in listening to the stories of others
than in hearing yourself tell your own.

You consciously choose not to be attracted to negativity.
Although you accept that we all have shadow within us,
you choose your friends based on how their positive
aspects enhance your own. When possible, you avoid
the company of people who are critical,
blaming, and draining.

. . .

You have no anxiety about attending your high school reunion
a few pounds overweight in a terrific outfit you've had
a few years.

. . .

You take better care of your car and your body—
you want them both to last a long time. Two words:
preventative maintenance.

Somewhere along the way you lost your fear of traveling alone—you've learned to appreciate solo trips as adventures, challenges, and learning experiences. Even when you travel with others, you wander off on your own more. You enjoy choosing lesser-traveled routes where you can get to know the natives and the terrain better. Increasingly, you'd rather have fewer destinations and more time to soak up the flavor of each place you visit.

. . .

You are willing to plan less and trust fate more.

. . .

You almost never offer advice. You trust your friends and loved ones to find their own way.

When other people insist on giving advice, you realize
it makes them feel better to give it. You listen for a
little while with an open mind and examine what you hear
for any possible golden nuggets of wisdom. If none surface,
you can comfortably ask, "Thanks for the thought, but do
I look like the kind of woman who needs advice?"

. . .

You've finally gotten over your fear of asking others for
guidance. Since your instincts are now sound enough to
pick guides who are truly encouraging, not manipulating
or draining, being mentored is no longer a threat, but a joy.

. . .

You know how to ask really good questions, yet you are
content at times to let people, places, and things
reveal themselves in their own way and at their own pace.

You realize that after forty, all the big adventures
are inner ones.

. . .

You go against conventional medical wisdom and
stop dreading menopause. No more cramps sounds
pretty good to you. Furthermore, as your cycles dwindle
you are pleasantly surprised to find that you enjoy
more even, constant energy in your life instead of the
monthly hormonal tides.

. . .

You listen to what doctors tell you about estrogen
replacement therapy with a large grain of salt.
You're comfortable consulting your inner wisdom
about what's right for you.

OTHER POSITIVE WOMEN BECOME
CLOSE FRIENDS, CONFIDANTES, AND FELLOW
ADVENTURERS. YOU EXCHANGE NAMES OF
GOOD ACCOUNTANTS, MECHANICS,
MASSAGE THERAPISTS, AND HAIRDRESSERS.

. . .

WHEN YOU DINE OUT OR ATTEND EVENTS
WITH A GROUP OF LIVELY WOMAN FRIENDS,
YOU NO LONGER a) ENVY THE WOMEN WHO
ARE PART OF A COUPLE, OR b) WORRY ABOUT
WHETHER PEOPLE THINK YOU'RE GAY.

Sex operates on many more levels than you
ever suspected possible in your younger years.
You find that you anticipate it more beforehand
and remember it better afterward.

. . .

You realize that it is not an Inflexible Law of the Universe
that you turn out anything remotely like your mother.

. . .

You do your best to forgive your parents for trying
to program you into what you could never be. You are
very good about encouraging the children you know
to discover what they are good at. You respect every
individual's right to live out his or her dream and life
purpose, not the dreams or agendas of others.

You realize that dreams and goals change.
If you want the same things at forty-five that you did
at fifteen or thirty, you either haven't evolved much or
you were smart enough to have been true to
yourself all along.

· · ·

Spontaneity, connection, and creativity are not a luxury.
They are a daily requirement.

· · ·

You consider disconnecting your cable TV
and buying a Jacuzzi instead.

You'd rather have one divine chocolate-chip cookie
from the best bakery in town than a whole box
of crummy ones from the grocery store.

· · ·

Sometimes you bake bread just for the sheer pleasure
of taking a hot, fresh loaf to friends who live alone and
have no one to cook for them.

· · ·

A sad-faced child stops you in your tracks.

· · ·

There is more diversity in your circle of friends than
ever before. Age, politics, income level, and education
matter less all the time.

It is gratifying to you when your friends genuinely like each other and form new connections that don't always include you. This makes you feel happy, not left out.

. . .

You stop trying to impose your will on the people who matter to you. Gently but firmly, you discourage them from trying to impose their will on you.

. . .

People change. You accept that personal growth is both inevitable and self-generated.

WHILE YOU TRY TO KEEP THE LINES OF
COMMUNICATION OPEN AND AVOID
EMOTIONAL CUTOFFS WITH DIFFICULT PEOPLE,
YOU REALIZE THAT YOU CAN'T WILL
HEALING INTO BEING. YOU ALWAYS TRY TO
OFFER OTHERS TIME, SPACE, AND A
SECOND CHANCE.

. . .

YOU SCOFF AT HOW THE MEDIA PORTRAYS
MIDDLE AGE. YOU WONDER WHO STILL BUYS
THOSE DUMB BIRTHDAY CARDS ABOUT BEING
OVER THE HILL. YOU FEEL A LITTLE SORRY FOR
WOMEN WHO HAVE YET TO HIT FORTY AND
FIND OUT HOW GOOD IT IS.

You look back on the struggles that women have
encountered and overcome through the ages—
how it took all their energy to struggle with the daily
chores of food, home, and child rearing—and appreciate that
there is no better time to be a woman or girl than today.
Tomorrow will be even better. You help foster this attitude
in women of all ages.

· · ·

Having just left them not so long ago, you know that
the thirties can be tough years for women. The teen years
can be rocky, too. You help gently steer women through
their identity crises so they can enter the next stage.
You do this by encouraging, never criticizing. Most of all,
you listen. The fact that no one did this for you makes you
realize how vital this role is.

You discover firsthand how great it is for women
of all ages and cultures to laugh together about
all the universal things that women all over the world
enjoy laughing about.

. . .

You talk back to your doctor.

. . .

You no longer believe everything you hear, yet know
that even lies usually contain a small particle of truth.

. . .

You decide that Eve was just a victim
of media bias and bad PR.

You are captain of your own ship yet, increasingly,
you are content to leave the big events of life up to fate.
You have sailed capably through enough storms
to know you can handle damn near anything.

. . .

You find large and small ways to be creative
every single day.

. . .

You have a style all your own.

. . .

If you have never painted your toenails, you start.
If you have done so since you were nine,
you stop for a while. Ditto for shaving your legs
and wearing eyeliner.

You find that when you stop trying to make the world notice you, applaud you, and love you, the world starts finding you much more lovable and worthy of notice.

. . .

You can imagine life without a man, a TV, or a car. Life without chocolate, bubble bath, or flowers, however, is unthinkable.

. . .

Chocolate becomes a sacrament.

. . .

It is so natural for you to encourage people that you are a little surprised and embarrassed when they go out of their way to show their appreciation for your help.

Now that you know how much more time
no-longer-young bodies need to heal,
you take better care of yourself.

. . .

You see bad news coming long before it arrives,
yet hope for the best.

. . .

You can't remember the last speeding ticket you got.
What's the hurry?

In traffic, you no longer tailgate. Other drivers' slowness
does not seem like a personal slight from the universe.
Now a slow car in front of you serves as a gentle reminder
for you to slow down yourself.

. . .

You empathize with the young—all those choices
to make and lessons to learn and consequences to suffer!
You also appreciate that while the younger generations
are overwhelmed by the burden of having
too many choices, people older than you
are weighed down by having too few.

. . .

Your faith becomes simpler all the time.

Your most generous acts are done without fanfare—
often anonymously.

. . .

At the same time that your spiritual life is getting simpler,
your investments may be getting more complex.
You make wise choices about who guides
and advises you in both areas.

. . .

Creativity is less something you do to impress other people
and more something that wells up spontaneously from within.

. . .

When you were younger, you thought you had to suffer
and heal alone, in silence. Now you know that love
and connection are the best doctors for body, mind, and spirit.

If you have to go into the hospital for surgery
or treatment, you don't mind your best friends coming in
to see you. You don't care how bad you look, and neither
do they. You enjoy the healing boost of positive energy
that comes from seeing their smiling faces.

When a friend is in crisis you never ask, "How did you
let this happen?" You ask what you can do—or make sure
the right thing gets done without your even
having to ask.

. . .

You get frustrated when you can't be creative
or solve a problem or make the world
a better place every day.

You return to the idealism of your youth.

. . .

You give up once and for all trying to seem cool
or hip or normal or anything else. Your goal is to be
rather than to seem.

. . .

You value the creativity of others at whatever level it occurs.
Even if it means listening, over and over, to your niece
play "Lady of Spain" on her new accordion, which she hasn't
quite learned to play yet.

. . .

Your desire to murder Martha Stewart for making you
look so bad is gradually replaced by a desire to sit down
with her over a good bottle of wine and get to know
the real Martha.

NOT ONLY HAVE YOU BECOME
REALLY GOOD AT CHOOSING WINE,
YOU ARE AN ACE WITH A CORKSCREW.

. . .

YOU NEVER TURN UP YOUR NOSE
AT FOOD THAT IS OFFERED TO YOU
IN GOOD FAITH.

. . .

MUSIC RESONATES LONGER.

When you are in the presence of a true master,
you are no longer jealous. You appreciate the chance
to soak up all that great energy.

· · ·

A little wine is all you need. You can't remember
the last time you had a really bad hangover.

· · ·

Once you stop trying to control every aspect of your world,
it's amazing how much better you sleep at night.

· · ·

Your need for alarm clocks and caffeine lessens
as you trust your body to wake you up at the right time.

You buy and wear less makeup, but you buy the best. You hardly ever let the lady at the cosmetic counter talk you into anything that isn't right for you.

. . .

You become so confident about what colors and styles work for you that sometimes you just saunter into a store and buy the perfect dress or top without ever trying it on. You know better than to try this with pants, however.

. . .

You hardly ever return clothes to stores because you don't buy them in the first place unless they are flattering, priced right, and different from everything else in your closet.

With every passing year, you buy fewer clothes
and give more of them to charity. You like the idea of
your clothes going out in the world to be brand-new
to someone else.

. . .

You enjoy the process of jettisoning all the old belongings
that you have outgrown in some way. This pleasure
far exceeds any satisfaction you would derive from
hanging on to stuff you no longer want or need.

. . .

You hardly ever say, "I don't have a thing to wear."
You don't mind people seeing you in the same outfit
any number of times.

Finally, you have learned the art of accepting compliments gracefully. You respond by smiling and saying, "Thank you," not by saying, "This old thing?" or by apologizing for breathing.

. . .

Even if you're still not sure which fork to use for what or how to deconstruct an artichoke in polite company, you have learned that the basis of good manners is, quite simply, consideration for others.

. . .

You smile when beautiful young men pass by, but don't get offended when they look right past you at the nearest twenty-something. Their taste in women will improve. Meanwhile, your favorite TV commercial is still the one about the office women watching the hunky construction worker take off his shirt and drink a Diet Coke.

FLIRTING IS LESS SOMETHING YOU DO
TO GET SOMEWHERE AND MORE OF A
MUTUAL APPRECIATION. YOU ARE CAREFUL
NOT TO START ANY FIRES YOU CAN'T PUT OUT.

. . .

YOU DON'T DO COY WELL. IF YOU LIKE
A MAN, YOU LET HIM KNOW.
YOU STOP MAKING MEN GUESS.

. . .

THINGS YOU GET THROUGH EXTENSIVE
MANIPULATION DON'T REALLY SEEM
WORTH HAVING.

You are more patient with individual people,
less patient with bureaucracy.

. . .

You hardly ever vote straight ticket.

. . .

Instead of going down to the local
smoke-filled bar, you stay home and lust after the
handsome, energetic male chefs on the Food Network.
A man who will cook for you is starting to sound better
than a man with a fat stock portfolio.

"Desperation," "rescue," and "love" are not words
you would consider using in the same sentence.

. . .

Simplicity in your life is not something you plan;
it's something you just notice happening.

. . .

Finally, failing memory works in your favor. Not only
have you lost the desire to harbor grudges—you've lost
the ability to! Furthermore, a week after you donate
a carload of stuff to Goodwill you can no longer
remember a single item you gave them.

You no longer confuse objects with people.
If you toss the sweater your late great-aunt Gertrude
knitted you twenty years ago, you don't feel massive
twinges of guilt. You do enjoy having objects around you
that remind you of people who loved you
when you were younger.

. . .

You clean your place before you leave on a trip
just to experience the joy of coming home
to a really clean house.

. . .

Quiet people interest you more.

44

You can spot a manipulator or predator a mile away. You feel compassion for women whose instincts are not strong enough yet to protect themselves from danger. You feel compassion for yourself if you were overly naive when you were younger. You help other women develop self-protective instincts.

• • •

If reading newspapers or watching TV news stresses you out, you feel free to cancel the paper or turn off the set. It's not that you are indifferent to the pain of the world; you just have better things to do with your time than absorb hours a day of bad news.

If you never learned to dance, you sign up for lessons
with a friend or by yourself.

. . .

No matter what the social setting, you always have
a pretty good idea what to wear.

. . .

You hardly ever hear of a sin you have not committed
on some level, or a mistake you haven't made.
There are very few crimes that you haven't at least
thought about committing.

.

You derive comfort from believing that
what goes around comes around. You are more willing
to leave payback up to the cosmos.

. . .

You are reluctant to give advice because you realize
that you are not the one to suffer the consequences.
The more you respect this, the more people
will ask you for advice.

. . .

If people offer you advice, you accept small doses
with a large grain of salt. Being subjected to
unsolicited advice only strengthens your resolve
never to be that way yourself.

You smile instead of flinch when people call you "ma'am."
After all, in Southern states it is a sign of respect
directly analogous to "sir."

. . .

If it says "Dry Clean Only" you almost always
put it back on the rack.

. . .

You trust your initial instincts about people but have also
learned the danger of snap judgments. Some of your
best friends are people you took awhile to warm up to.
Increasingly, you are content to get to know people
over time and in various settings.

When someone needs to talk to you, you quiet
your own reactions so as to focus better
on what she is telling you.

. . .

You realize that the world doesn't end when strangers
no longer gaze at you admiringly and pay you lavish
compliments. In some ways, your attractiveness
is just beginning, not ending.

. . .

You gaze up at the stars and wish you had been born
100 years later so you could help colonize deep space.

. . .

You view the first forty years of your life as a warm-up—
kind of an informal dress rehearsal.
The best is yet to come.

YOU TREAT HOMELESS PEOPLE WITH RESPECT
AND WITHOUT JUDGMENT.

. . .

YOU VALUE EGO LESS, SOUL MORE.

. . .

FLOW INTERESTS YOU MORE THAN CONTROL.

. . .

READING IN BED IS MUCH MORE FUN
THAN WATCHING TV.

You respect all true healers.

. . .

You are better at listening to your body.
You attend to warning signs sooner and almost never
push to the point of exhaustion.

. . .

You know what phase the moon is in
without even looking.

. . .

Positive is not something you set out to be—
you just start waking up that way more often.

You worry less.

• • •

About the only time you lose sleep is when
you realize afterward that you might have
hurt someone's feelings unintentionally.

• • •

Everyone exaggerates a little, but you have
a low tolerance for untruths.

• • •

Time has become precious enough that you are less willing
to let people waste yours.

You never snap at, reprimand, or tease waitresses
or store clerks. It helps to remember when that was
the only kind of job you could get.

. . .

Mentoring the young seems like a natural thing for you to do.
Remembering the times when people helped you
makes you want to pass on the favor. You know firsthand
what a difference a few encouraging words can make
to someone who is unsure.

. . .

You are less and less willing to spend large amounts of time,
money, and energy on trying to look ten years younger.
You find that as you accept more and control less,
the years fall away naturally.

You'd rather be a youthful wise woman
than an aging girl.

• • •

Even though most rap music sets your teeth on edge,
you remember how much fun it was to set
your parents' teeth on edge with your music.
You appreciate that rap is the perfect revenge on the
tender sensitivities of the hippie generation.
If you were young now you would probably like it, too.

• • •

At heart you still have hippie values and let them
show more as you get older.

Hardly anyone—even your mother—has the power,
the right, or the ability to make you feel
guilty or inadequate.

· · ·

You trust the universe more and set your car alarm less.
You still lock the doors at night, however.

· · ·

People remember your laugh.

· · ·

Unless someone you know encounters amazing
good fortune, you never say, "I told you so."

You don't believe for one minute that suffering
in childhood builds character. What it really does
is stifle budding souls.

. . .

You no longer admire martyrdom.

. . .

When you hear one of your parents' favorite songs
from their youth, it doesn't sound too bad.

. . .

When you watch old reruns of *Bonanza*,
Lorne Green starts to look pretty hot.

You keep a book in the car for traffic jams or
long waits at doctors' offices.

. . .

You and your girlfriends can still carry on spirited discussions
over who the cutest Monkee or Beatle was. Chances are
that you are either still loyal to Mike Nesmith and
George Harrison (the smart, quiet ones) or liked goofy
Ringo and Peter Tork the best. Having crushes on
Paul or Davy was way too obvious.

. . .

Once your children or nieces or grandchildren
are old enough, you are not embarrassed to tell them
a little about your younger years. You might even tell them
about the times you danced to the drum solo of
"In-A-Gadda-Da-Vida" or to the Australian national anthem.

Although you are in touch with your fears and doubts,
you refuse to let them come first.

· · ·

You realize that everyone, including you, has blind spots
and emotional/psychic land mines. You try to steer people clear
of yours and respect those of others.

· · ·

You ask fewer questions that can be answered
"Yes" or "No" and more that start with "Tell me about . . ."

· · ·

People trust you. In return, you are very careful
never to give them reasons not to.

For the most part, you can forgive men for acting like men,
unless their behavior feels belittling or threatening to you.
You feel a little sorry for men—they are victims of
societal conditioning more than most women are.
Most of the time you are very glad not to be male.

• • •

When in doubt, you prefer to err on the side of generosity
and sleep better at night.

• • •

For both men and women, you think flat stomachs
are highly overrated.

Rather than feeling jealous, you actually feel
some compassion for men of your generation when you
see them with sweet young things half their age.
The men always look so tired.

. . .

Not only do you have your own power drill,
you know how to use it.

. . .

You take really good care of fragile old handmade quilts
so you can pass them on to the next generation.

Your nephews and nieces and grandchildren adore you for at least attempting to understand and play their Nintendo and PlayStation video games. Even if you never make it past the first level of Donkey Kong, they love you for being a good sport and for trying.

. . .

You can remember what it feels like to love with all your heart. It would never occur to you to discourage anyone else from finding out what that feels like.

. . .

You understand that it is impossible for true love ever to be wasted or thrown away. Love multiplies.

Acting your age and not your shoe size
is not always a desirable scenario.

. . .

When no one is looking, you go play on the
swing set in the park. The older you get,
the less you care whether anyone is looking.

. . .

Harold and Maude is still one of your favorite movies.
Only now you identify more with Maude, not Harold.

. . .

You care less about whose fault a problem is and
more about not only how to fix it but how to
keep the same problem from reoccurring.

Noticing that men no longer turn to stare at you
on the streets is a good thing. Your feelings aren't hurt
in the slightest.

. . .

You are more concerned about how a bra feels
than how it looks, but if you are persistent, you find one
that fits you well and comes in your favorite color
with lots of lace.

. . .

Even if—especially if—you are not dating
or involved with anyone, you buy yourself pretty, lacy,
sexy, comfortable lingerie in your favorite colors.

WHERE AND WHEN APPROPRIATE, YOU LET
YOUR GUARD DOWN SOONER WITH THE
RIGHT PEOPLE AND ARE BETTER
ALL THE TIME ABOUT KNOWING WHO
THE RIGHT PEOPLE AND WHAT THE
RIGHT CIRCUMSTANCES ARE.

. . .

WALKING INTO A ROOMFUL
OF STRANGERS IS NOT THE WORST THING
IN THE WORLD ANYMORE.

YOU'D RATHER PEOPLE BE KIND
THAN SHREWD.

. . .

YOU ARE AWARE THAT THE SECRET
OF BEING A COMPLETE BORE
IS TO TELL EVERYTHING.

You have increased confidence in your ability
to handle and even enjoy situations—
like public speaking or singing a cappella—that used
to make you quake with fear.

· · ·

Maintaining comfortable ties with your
family of origin is important, but you have learned
what works for you. You find that shorter,
more frequent trips back often work better
than one long, obligatory yearly visit.

When you find yourself getting impatient with what seems like the limited awareness of others, you remind yourself that everyone is entitled to her or his own level of perception.

• • •

You acknowledge the rights of all to experience and express a full range of feelings.

• • •

You are kind to the clueless because you remember all too well when you were clueless, too.

• • •

You can make gentle fun of yourself without putting yourself down or feeling sorry for yourself.
You enjoy good-natured teasing with the people you love.

You didn't get to choose your family but you do
get to choose your friends, who ultimately
become your family.

. . .

While you refuse to let telemarketers waste your time
or sell you things you don't want, you feel kind of sorry
for anyone who has to do that for a living. You never,
ever slam down the phone.

. . .

Instead of feeling jealous of younger women,
you remember how hard it can be at that age
to be yourself and to be given credit for any intelligence.
You make a point of trying to boost young women's
confidence levels, not take them down a peg.

Sometimes, you admit it, you glance at those dumb
articles in the women's magazines in the grocery store
checkout line. When you read those articles about
"How to Drive Your Man *Wild* in Bed and Make Him
Your Eager Love Slave" you realize—rather smugly—
that you are far more knowledgeable on the topic
than whoever wrote the article.

You don't waste a lot of time or energy on
anyone who, for whatever reason, is unable to appreciate
what you are about.

• • •

Men don't intimidate you anymore—you can hold
your own. You have learned to value a gentle man
more than an angry one.

When people let their guard down with you
and are vulnerable and personally revealing, you take this
as a compliment and are careful never to use
their words against them in any way. You value these
qualities in others.

. . .

Once you resolve your own relationship control issues,
you see the battle between the sexes for what it is:
media hype.

. . .

Real love is way better than it is in the movies.

. . .

Most men need us more than we need them.

Intimacy is a realistic goal and a delight,
not an impossible dream or a threat. It is well worth the time
it takes to build.

. . .

You can easily tell the difference between
intentional and unintentional harm.

. . .

You work at making the world a guilt-free zone.
Remorse and regret are one thing; guilt is quite another.
No one should ever be made to apologize for
having been born.

While you have immense compassion for victims,
you do not have a great deal of patience for the
chronically self-pitying. Life has taught you that there
is a huge difference between surviving and thriving.
Your forties are a great time to hone in on this major
distinction—and put it into practice. No effort that
you put into forgiveness and letting go of past pain
is wasted.

. . .

You have no trouble believing—and even admitting—that many
parts of you are excellent.

Although you are a very competent lover,
sex is less about stamina and technique than it is
about intimate connection and dissolving boundaries.

. . .

Sex is no longer a metaphor for power.
It is a metaphor for union.

. . .

You can actually laugh during sex.

. . .

Reluctantly but relentlessly, you floss every day.

Desire no longer needs to be acted on immediately.
Smoldering can be fun.

. . .

You have outgrown the need to hire decorators
or furnish rooms based on pictures in glossy magazines.

. . .

You enjoy leaving coins in the change slots of pay phones
for others to find.

. . .

If you drop a dime, you would rather leave it
on the ground for a little kid to find.

Ambiguity is more intriguing than many certainties.
You've come to enjoy the slow unfurling of mysteries.

. . .

You are calmer in the face of death and illness than
you used to be. You are strong enough now to
help others grieve.

. . .

When directness is called for, you do not shy away.

. . .

Except in a life-or-death situation, you never protect
people from their own consequences. To do so would
impede their learning process.

THERE IS A LAND BEYOND BLAME.
YOU KNOW THIS BECAUSE
YOU HAVE BEEN THERE.

. . .

YOU NEVER GET INVOLVED WITH ANYONE
YOU CAN'T BE FRIENDS WITH BEFORE,
DURING, AND AFTERWARD.

It would not compromise or bother you to introduce
a good friend to an old lover with whom things
just didn't work out for you.

. . .

You see that jealousy is nothing more than insecurity.
If you feel it welling up inside you, you can easily
acknowledge it as such. Once you have done that,
you can let it go.

. . .

You understand the difference between pleasure and joy.
One is ephemeral, the other lasting. Yet a balanced life
needs both.

As time passes, your pleasures become simpler
at the same time as your income taxes and
investment strategies become more complex.
If you need to or want to, you can probably live on
way less than what you currently make.

. . .

You do your financial homework. You refuse to invest
in companies you would not want to work for personally
or have in your own backyard.

. . .

As you enter your middle years, you get more idealistic,
not less. You enjoy the company of people who are
passionate about what they believe in.

You are able to see cynicism for what it truly is:
the last defense of a tender and wounded heart.

• • •

Your favorite poem used to be "La Belle Dame Sans Merci."
Now your favorite line is "When I am an old woman,
I shall wear purple" from "Warning" by Jenny Joseph.

• • •

You realize that the truly cool people in this world
seldom give a damn what anyone thinks of them. You see
the wanna-be cool pose of the young for what it is: a
reluctance to be passionate about life. You find yourself
preferring the company of people who dare to be passionate
to the company of people who think they are cool.

You don't water your garden according to what day of the week it is or what the gardening books tell you. You water when your plants look tired and thirsty.

• • •

You recognize your own tired and crabby moods and are careful to take extra good care of yourself at such times. You know better than to make important decisions when you are tired, bored, lonely, hungry, angry, and/or depressed.

• • •

Especially if you have not done so before, the forties are a great time to take a younger lover. But only if it makes you feel younger, not older.

YOU BUY YOURSELF FLOWERS ANY DAMN TIME
YOU FEEL LIKE IT.

. . .

YOU WISH YOU COULD HAVE KNOWN
YOUR MOTHER AND GRANDMOTHERS
WHEN THEY WERE YOUNG.

. . .

YOU NEVER SAY "LET'S KEEP IN TOUCH"
UNLESS YOU REALLY MEAN IT.

Little kids love coming over to your house for visits.
You encourage their parents to drop them off for the day,
the night, or a weekend—it's good for the parents,
the kids, and you (especially if you never had children
yourself). Everyone runs around in their PJs and
watches cartoons together. You let them have nachos
or pizza for breakfast, SpaghettiOs out of the can for
lunch, and cold cereal for supper. After they leave
there are always wonderful new pictures proudly
taped up on your icebox.

When you see a smiling, attentive, perfectly coiffed
political wife standing supportively next to her husband
on a stage, you always wonder what her life is like—
what her private joys and sorrows are—whether she
is happy. You also wonder how much of his speech
she wrote.

. . .

You don't date men you feel sorry for.

. . .

You can let doubts about a person or situation
sit on the back burner and simmer a bit
until patterns emerge.

You understand that no matter how encouraging you are,
people do not let their defenses down until they are ready.

. . .

As you learn to enjoy process more, you are
less outcome-oriented all the time. You have learned
that when you relax your will and leave more up to Fate,
she brings you more abundance than you might ever
have dreamed of or dared hope for.

. . .

You always hope for more than you expect.

Having been hurt before does not make you
stop trusting. It just makes you a little choosier
about whom you trust. Past pain does not make you special.
Transcending it, however, does.

. . .

You can express your needs and admit fears
to yourself and others. You are not threatened
when others do the same with you.

. . .

Your pity is reserved for people who tried really hard
to be good people and got blindsided by fate.
Watching footage of disasters, like tornadoes and floods,
makes you sad.

You care less about the size of a friend's or
potential lover's bank account and more about how
being with that person makes you feel.

. . .

You are no longer charmed by or attracted to what
is bad for you. Bad boys are just that. You are *so* over them.

. . .

Whatever life offers you, you are always able to
smile and say, "No thanks."

Whatever you have lived through and survived and overcome,
it all went into the making of you. You give yourself credit
for having turned out pretty well, all things considered.

. . .

It's easier to find your natural balance in all things.
Increasingly, life is ebb and flow, high tide and low tide,
yin and yang. When a new element arises, you don't worry
about how you are going to handle it. Instead, you
wonder how it will affect your current balance.

You compete less with others but set high standards for yourself. It is important to you to always be on some kind of quest, large or small. It doesn't matter whether you are striving toward finding your perfect lover, getting a rare glimpse of the almost-extinct Audubon's crested caracara, writing the world's tenderest and most romantic love song, or tracking down the perfect vintage tablecloth to go with your collection of antique Blue Willow china. We all do better if we have at least one moderately impossible dream.

You probably enjoy collecting something—be it nineteenth-century netsuke, antique lace, or Texas barbed wire—but not obsessively or exhaustively. Your collection is important to you, but you try not to bore others with it (unless, of course, they are fellow collectors).

. . .

You learn to accept what you cannot forgive.

. . .

Melodrama bores you.

Even if you are on a diet, you always buy chocolate from kids whose parents or teachers make them sell candy door-to-door. They get Brownie points and you get to eat the chocolate. However, you draw the line at magazine subscriptions.

· · ·

You know that while pain and loss are inevitable, suffering is not.

· · ·

You don't mind cutting your own lawn. But when an earnest little kid shows up with a lawnmower and says, "Lady, can I cut your grass?" you are a pushover and probably pay more than the asking price.

As you take walks around your neighborhood,
you keep an eye out for people or stray animals
who might need a little help.

. . .

Your life experience has made you very aware of patterns.
You understand that life keeps throwing the same lessons
at you—over and over—until you pass the test
and move on to the next level.

. . .

You refuse to let the sorrows of the world
embitter you or make you an emotionally stingy person.

When you look at yourself in the mirror, you smile
more often than you frown. You give yourself full credit
for being stronger than everything that has ever
tried to do you in.

. . .

You are wary of predators.
You dare to champion innocence.

. . .

It took you awhile, but you have learned
the difference between instinct and impulse.
Instinct runs much deeper. You can easily distinguish
among a whim, a pipe dream, and a mission from God.

FINALLY, YOU STOP APOLOGIZING FOR YOURSELF.

. . .

YOU ARE SUSPICIOUS OF ANYONE WHO
CLAIMS TO HAVE FOUND THE ONE TRUE PATH,
ALWAYS GOT IT RIGHT THE FIRST TIME,
AND/OR NEVER MADE A MISTAKE.

. . .

EVENTUALLY, EVERYONE AND EVERYTHING—
SYSTEMS, INSTITUTIONS, FAMILIES—HAVE TO
EARN AND MAINTAIN YOUR RESPECT. NO ONE
GETS IT BLINDLY OR AUTOMATICALLY.

Though the results are not yet in, you are skeptical
of theories that attribute all mood, motivation, and
behavior to biochemistry and genetics. DNA is not
destiny. We all have the power to work wonders
with the hand life deals us.

. . .

Your circle of friends includes both introverts
and extroverts.

. . .

When a friend introduces you to her new lover—
the one you've been hearing so much about—you are
less impressed by his looks or his financial situation
than you are by how happy your friend is looking.

You avoid making snap judgments about other people's
relationships based on how they look from outside.
Your own experience has taught you that no outsider
knows what goes on between two people when
no one else is around.

· · ·

You value the creative process itself—at whatever level
it occurs—over product. Yet your greatest respect is reserved
for those artists and creators who dare to turn their visions
and great ideas into reality. You'd rather read a friend's
first-draft novel-in-progress than listen to her talk endlessly
about the great book she is going to write someday.
If she is a really good friend, you will figure out an
encouraging way to tell her this.

"Should," "ought to," and "got to" have become
less frequently used words in your vocabulary.

. . .

You would have more respect for the Ten Commandments
if the eleventh commandment—or the first one—
had been "Honor and cherish all the children of the world."

. . .

At least once you have proven that you can spend
major holidays by yourself. In fact, it's kind of fun.

. . .

You trust people to form and maintain
their own connections.

You talk less so that others can talk more.

. . .

In an adult, helplessness is no longer an attractive trait.
You respect that all people have crosses to bear and
challenges to overcome. But unless they are children or
very ill or elderly adults, you do not acknowledge wounded
people's right to blindly take their problems out on you
or the rest of the world. Reasons are not always excuses.

. . .

After more burst bubbles than you might care to admit,
you have learned that the more unrealistic your expectations
are, the more likely you are to be disappointed. Yet you
never point this out to other people or try to rob them
of their hopes. Life has a way of grounding us and
helping us separate the wheat from the chaff.

PERFECTION IS WHATEVER IS JUST RIGHT
FOR YOU. PERFECTIONISM IS WHAT KEEPS YOU
FROM FINDING OUT WHAT THAT IS.

. . .

LIKE A SLIGHTLY OLDER, WISER GOLDILOCKS,
YOU EXPLORE WHAT THE WORLD OFFERS
YOU AND THEN SETTLE DOWN INTO
WHATEVER FEELS JUST RIGHT. YOU ACCEPT
NO SUBSTITUTES.

. . .

YOU ALWAYS KNOW WHEN ENOUGH IS ENOUGH.

In a few chosen areas of competence, you take major creative risks and dare to be great. You refuse to compromise—you master your art and your craft, study with the best teachers, and seek excellence in the fields you are most suited to. In other areas, you dare to be merely average—a very different kind of risk. You take a different kind of pleasure in being only moderately competent in areas you once avoided altogether.

• • •

If you have always been bad at math, you learn enough to get by in the world. If necessary, you bribe a fifth grader to teach you things you are fuzzy on, like long division. If you are a math whiz you might try painting, or rounding off numbers for a change.

If you have always thought of yourself as an
uncoordinated klutz, you either accept it or do something
about it (ballet lessons, yoga, fencing or boxing practice,
or simply paying more attention to where you are going).

. . .

You still love to play kickball.

. . .

Rather than feel stupid or inadequate in an area you
are not naturally good at (math, cooking, bookkeeping,
housework, car maintenance, yardwork) you either
overcome your block and master the basic skills, pay someone
to take over the duties for you, or barter with friends
and neighbors.

The best lover for you is neither dominant nor submissive to you, but a fellow traveler on the road of life.

. . .

Short periods of low energy do not necessarily indicate major depression or despair, though you monitor yourself closely at such times. Sometimes your body, mind, and spirit need to rest up from something you've just accomplished, or get ready for whatever lies ahead. Like Persephone, you learn to put your time in the underworld to good use. Nature operates on cycles. You are no exception to this.

Taking risks and operating in sight of the Edge is great—
at times, all creative people have to burn the candle
at both ends. Not to mix metaphors, but you maintain
enough balance to keep from getting burned and/or falling in.
This applies to any form of addiction, risk, indulgence,
or obsession. Over time you've lost a few too many
people this way.

· · ·

Whether it's a job, a man, or a new car, you refuse
to fall in love with something that is bad for you,
more than you need or can handle,
or belongs to somebody else.

If you have been a shy, quiet woman most of
your life, you speak up, reach out, and take more risks.
If you have always been good at connection and
communication, your forties are a great time to
explore your quieter, more spiritual aspects.

· · ·

When people ask you for advice, you reassure
them that they probably have all the information
and inner resources they need to make the best decision,
but what they might need is to give themselves
a little time. You apply this advice to yourself, as well.

You don't ignore your body's warning signals, but neither do you become a Camille. You observe, research, ask lots of questions, and hold off decisions until you feel you have all the facts. You are not afraid to let a little time go by to see whether your symptoms lessen or improve.

. . .

Overall, you've stopped comparing yourself to others. Apples will never be oranges. And nothing rhymes with orange.

105

It's been a long time since you broke rules just for the sake of breaking them. Yet you will never blindly follow rules, either—you still have a healthy disrespect for much of what passes for authority. To quote Jimmy Buffett, you'd probably still rather ask for forgiveness than permission.

You refuse to make fun of Mick, Bruce, Elton, Dylan, Joni, Neil, Bob Seger, Eric Clapton, James Taylor, and all the other rock icons of your youth who are still recording and touring in their fifties and beyond. So they're showing their age. Who isn't? Rather than listen exclusively to their old stuff, you buy their new music, attend their shows, and otherwise show your appreciation not just for what they meant to you way back when, but for what they have evolved into. You respect all they have represented as well as all they have survived.

IF YOUR HOUSE IS TOO BIG OR ELABORATE
FOR THE NEW YOU, YOU GET A SMALLER PLACE.
IF YOU HAVE ALWAYS LIVED IN A
SMALL CITY APARTMENT, YOU CONSIDER
A MOVE TO THE COUNTRY.

. . .

YOU FIND A LITTLE TRUTH IN EVERYTHING
YOU SEE AND HEAR.

YOU ARE NATURALLY ATTRACTED TO WHAT
SUSTAINS YOU. YOU DODGE OR DEFLECT
EVERYTHING THAT TRIES TO DRAIN YOU.

. . .

"GUMPTION" HAS BECOME ONE OF YOUR
FAVORITE WORDS. YOU PLOT WAYS TO BRING IT
BACK INTO WIDER USE.

Secretly, you think Garrison Keillor is kind of handsome.
You like his voice and the way his soul shines straight
out of his eyes. You don't quite get what people see
in Leonardo DiCaprio except a pretty face.

· · ·

You realize that fate is random and impersonal.
You try not to take this too personally.

· · ·

You don't mind friends, relatives, complete strangers,
or your lover seeing you without makeup.

All a bad hair day really means is that when the people who see you with your hair messy and standing on end catch a glimpse of you all dolled up and resplendent, they will gasp, keel over in amazement, and refuse to believe it's really you.

. . .

While you accept that loss is inevitable, you wisely keep all your valuables appropriately appraised and insured.

. . .

You have moved from having a number of one-on-one or two-couple friendships with people who are a lot like you to a diversified assortment of friendships with single people, couples, families, and entire groups.

You know when to be gracious and accommodating
(at least 90 percent of the time), but also when to
let politeness go by the wayside.

. . .

You know that the best song or the most beautiful poem
or painting was worth writing or painting even if
no one ever hears it or sees it. But experience tells
you that the world will not clamor to the artist's door
begging for access. The artist must get her work out
where it can be heard, compared, and experienced.

The best celebrations are spontaneous ones.
You may run out of laundry detergent or nail polish remover,
but you are always careful to have at least one bottle
of champagne in your refrigerator.

. . .

There is no shortcut to happiness. Once you accept this,
you find happiness springing up around you
in all sorts of unexpected forms.

THE BEST CONVERSATIONS
INCLUDE SILENCES THAT ARE AS MEANINGFUL
AS ANY WORD OR PHRASE.

. . .

YOU HAVE SEEN AND EXPERIENCED
ENOUGH PAIN TO KNOW THAT SOMETIMES
PEOPLE NEED TO BREAK DOWN
TO BREAK THROUGH.

You are wary of halfhearted or conditional love, if in fact
such conditions can be referred to as love.

. . .

Depression is a signal for change (positive) more often
than it is a cry for help (negative), though you are
sensitive to both possibilities.

. . .

"Laziness" is no longer a negative word.
You're merely conserving energy.

You believe that guilt as a way of life is not healthy
for people or for the world in general. But you think
people should feel a little guilty—or at least remorseful—
every time they are mean, untruthful, or wasteful.

. . .

If you live in a cold place, you make a point
of visiting warm, languid places where people
move and talk very slowly.

If you live in a warm climate, you visit a cold place in winter every few years just to remember the magic of freshly fallen snow. Such visits also enhance your appreciation for living in a place where shoveling snow is an alien concept.

· · ·

When life gives you sour grapes, you make sangria.

· · ·

You have no interest in ever being a workaholic or even a chocoholic. One day while taking a bubble bath, however, you coin the phrase "joy-aholic" and decide that there are worse things to be remembered for having been.

YOU GIVE YOURSELF PERMISSION
TO BE SURPRISED BY JOY.

. . .

YOU READ FEWER TRUE CRIME STORIES
AND MORE C. S. LEWIS.

WHATEVER YOUR BELIEF SYSTEM,
YOU ACCEPT THAT BOTH GOOD FORTUNE
AND BAD ARE FAR MORE THAN
BLIND LUCK.

. . .

YOU CAN'T REMEMBER THE LAST TIME
YOU DIDN'T THINK YOU HAD THE RIGHT
TO BE HAPPY, LOVED, LISTENED TO,
OR UNDERSTOOD.